i wotmo

saddle SATUL

POLiSH by the

morning

would you

geta

patfor me?

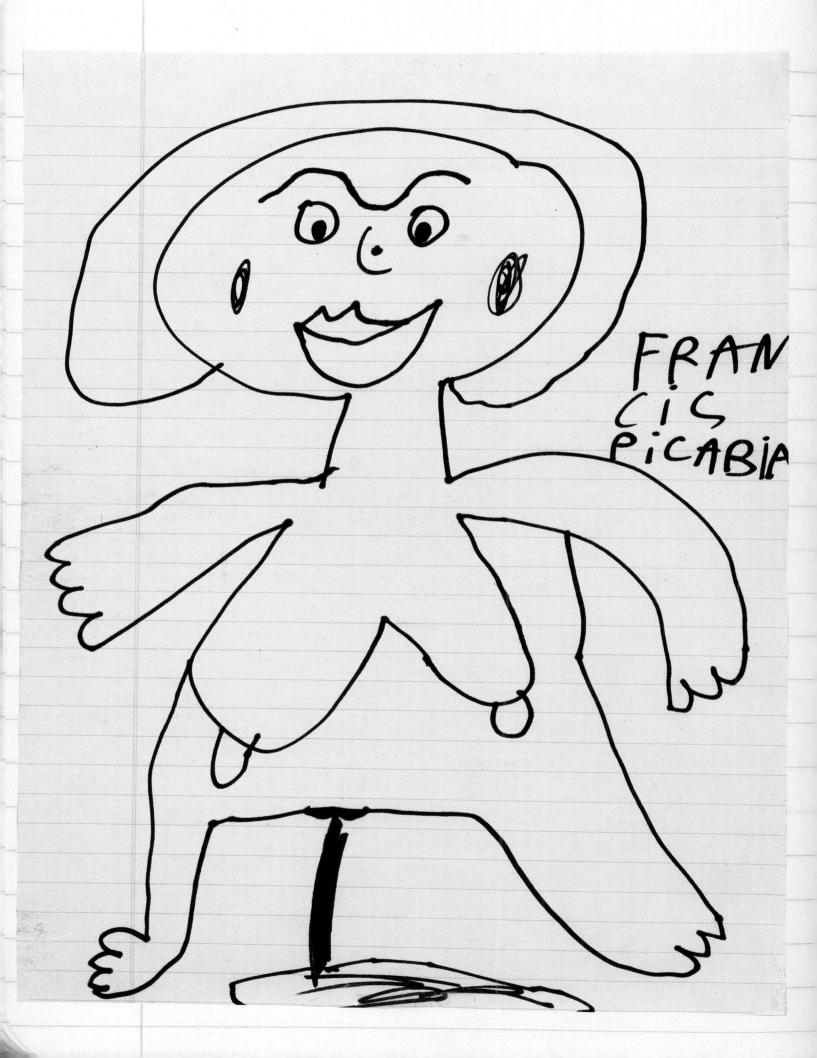

FRAN
CIS
PiCABIA

A·T RANDOM

FRom LoLA ToVITo

KYOTO SHOIN

First published in Japan 1990 by KYOTO SHOIN INTERNATIONAL Co., Ltd.
Sanjo agaru, Horikawa, Nakagyo-ku, Kyoto, Japan. TEL[075]841-9123

Editorial director : Kyoichi Tsuzuki
Art director : Ichiro Miyagawa

ISBN4-7636-8546-5 C0371 P1980E

Printed and bound in Kyoto by SHASHIN KAGAKU Co., Ltd.

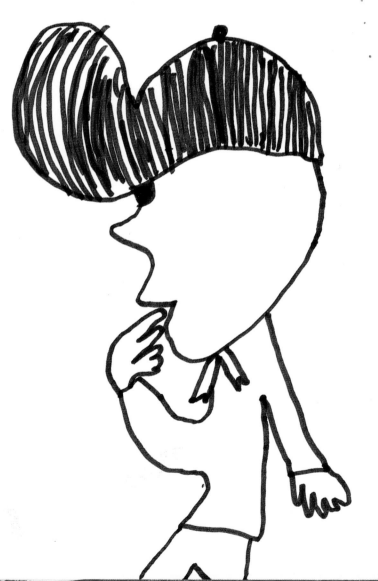

PAPA I STELLA

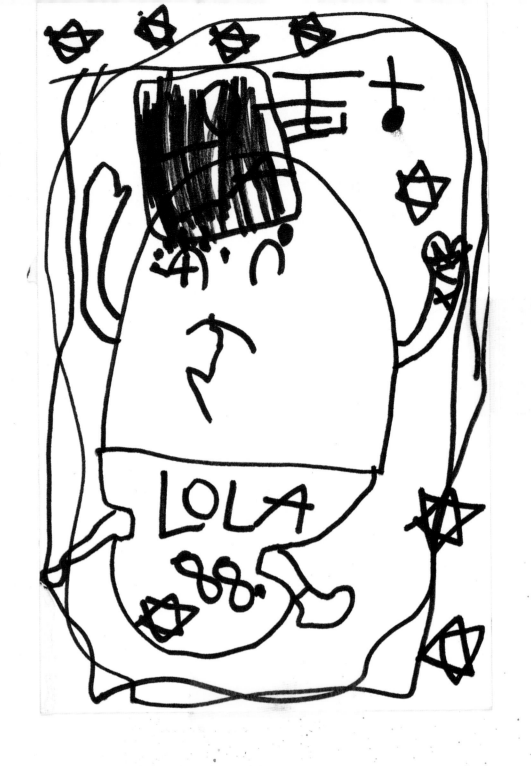

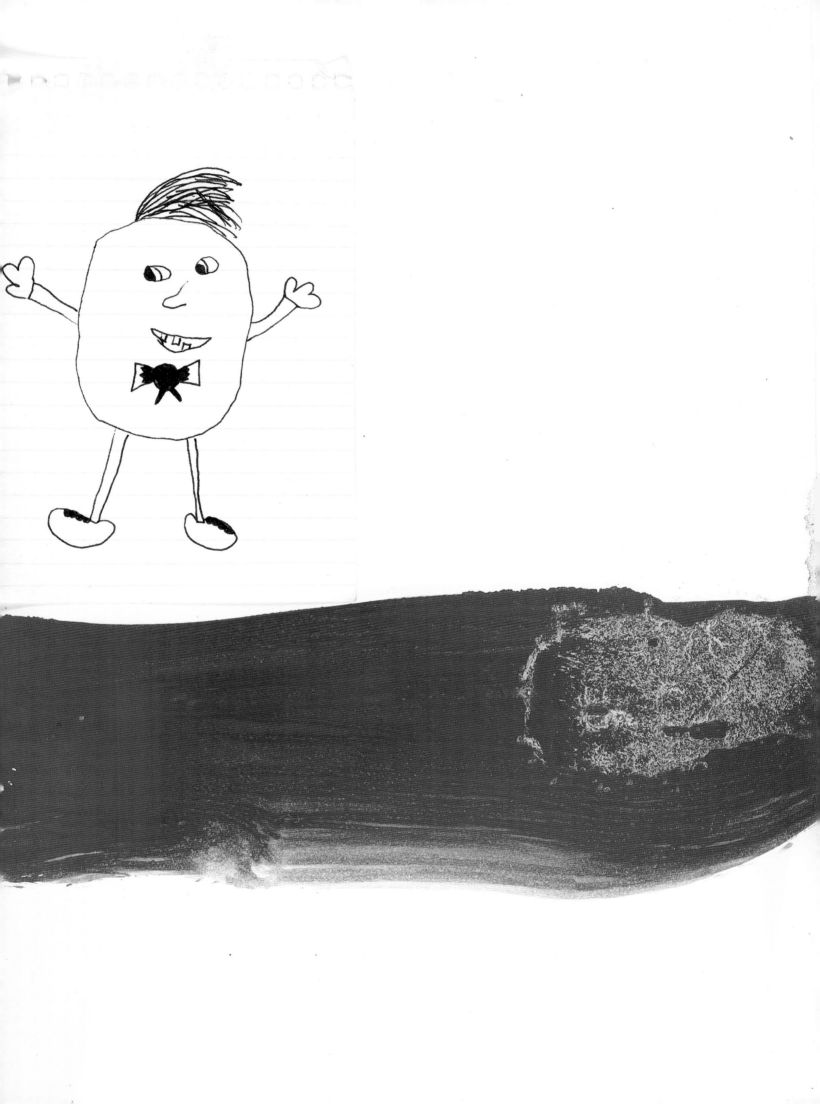

Ex to
Sc
PR
An
v.s.

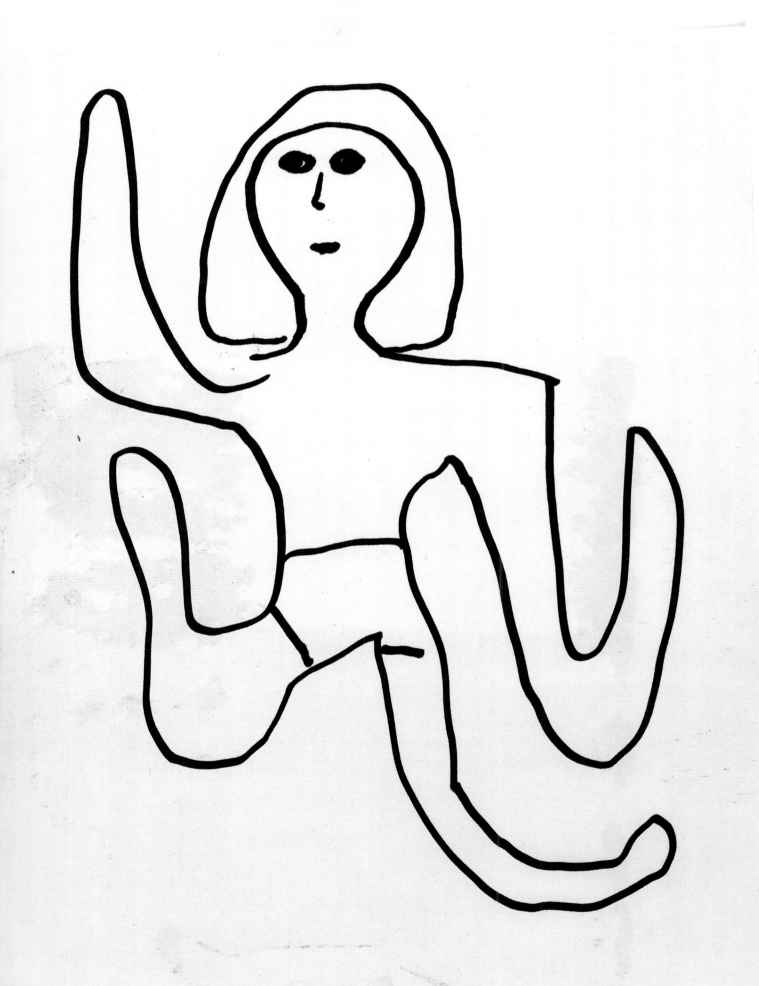

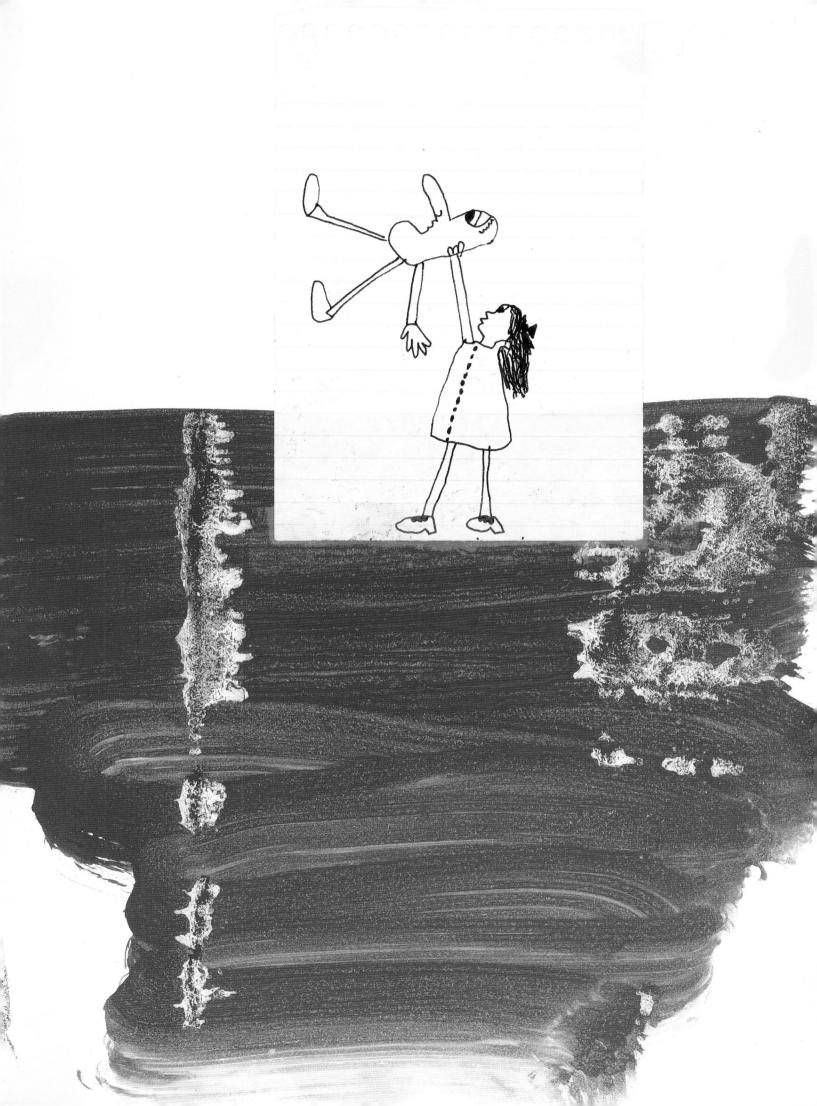

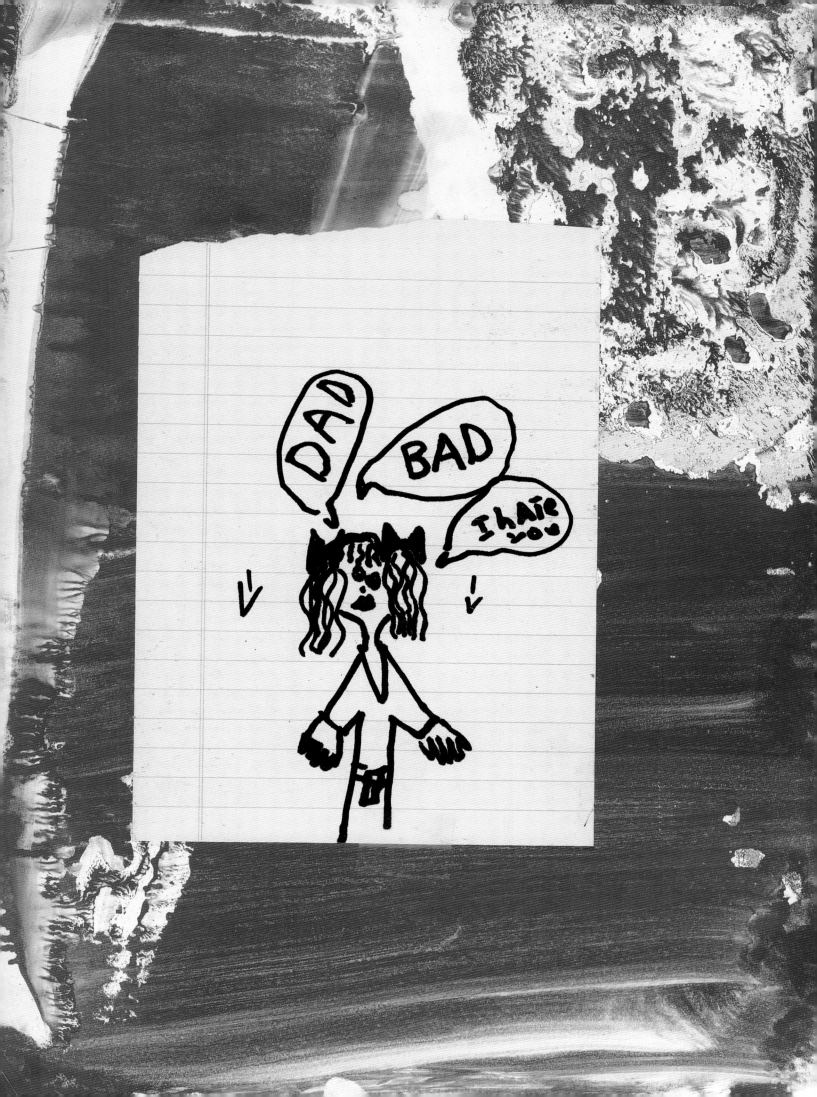

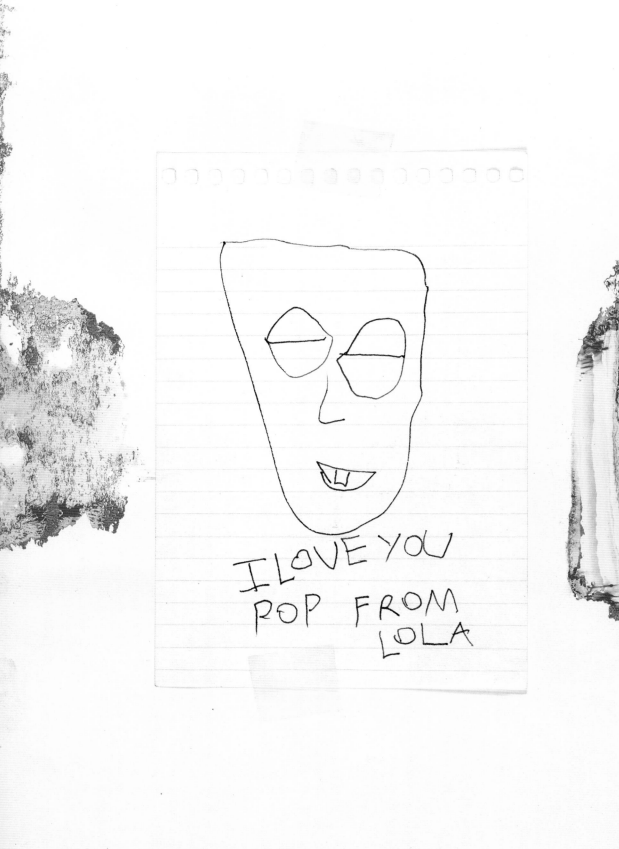

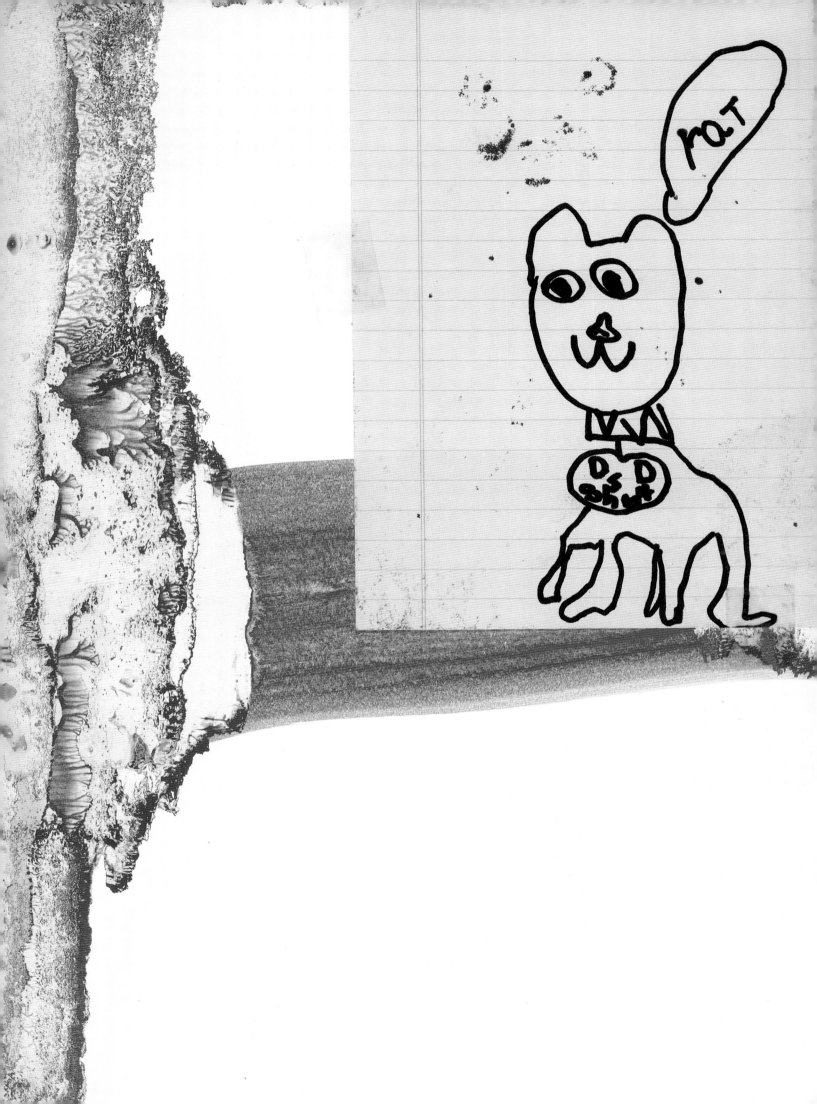

I
YO
S
W
K

OVE

MOMMI

LAK

S

me

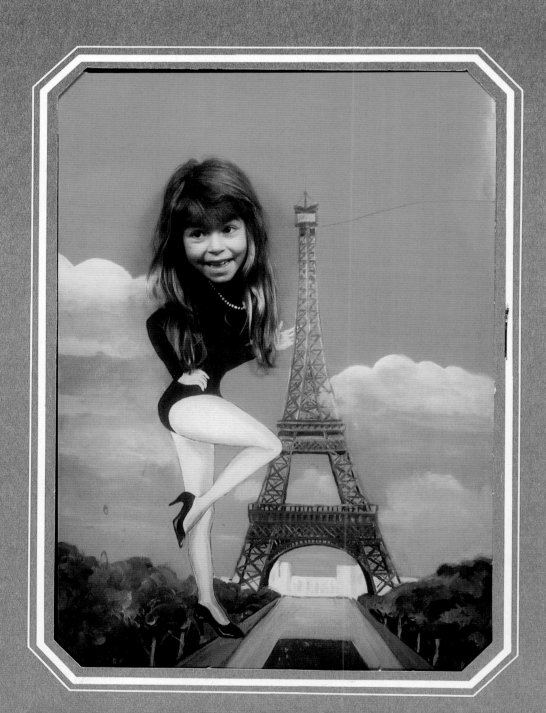

STUDIO DE LA TOUR EIFFEL
Champ De Mars
PARIS 7ᵉ
SIRET 784 291 841 00012

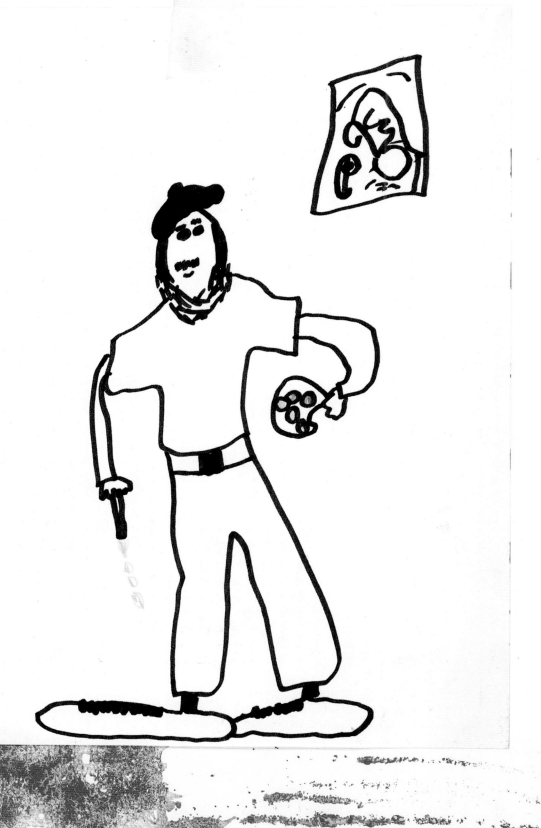

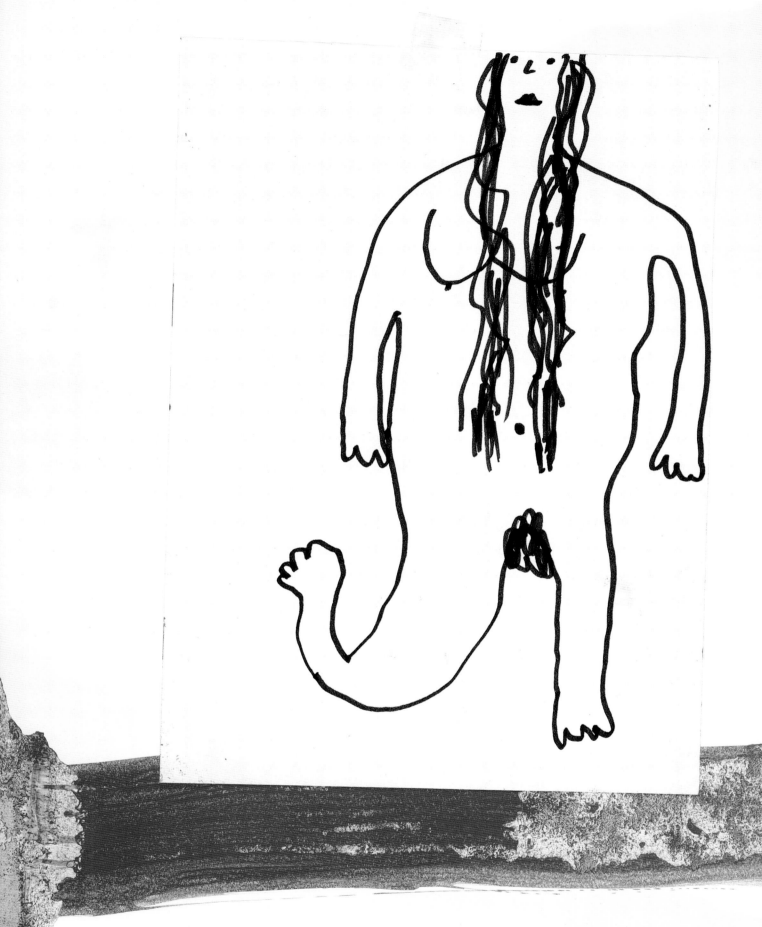

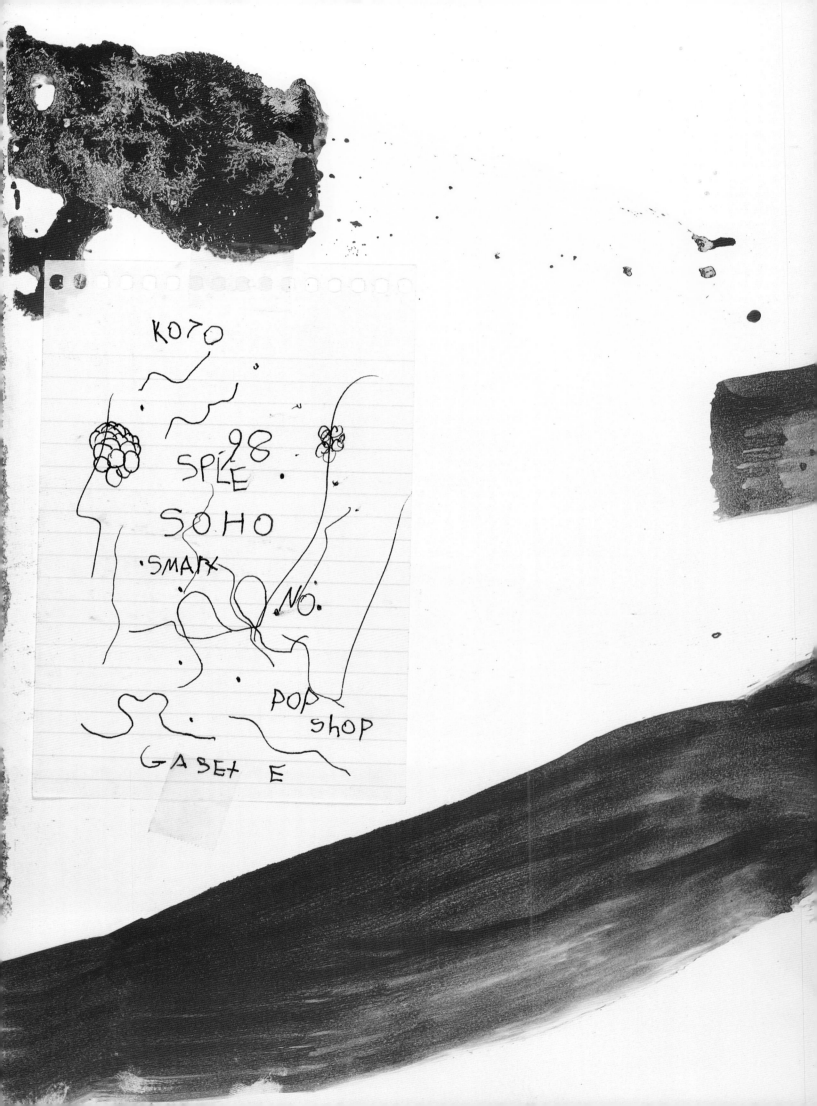

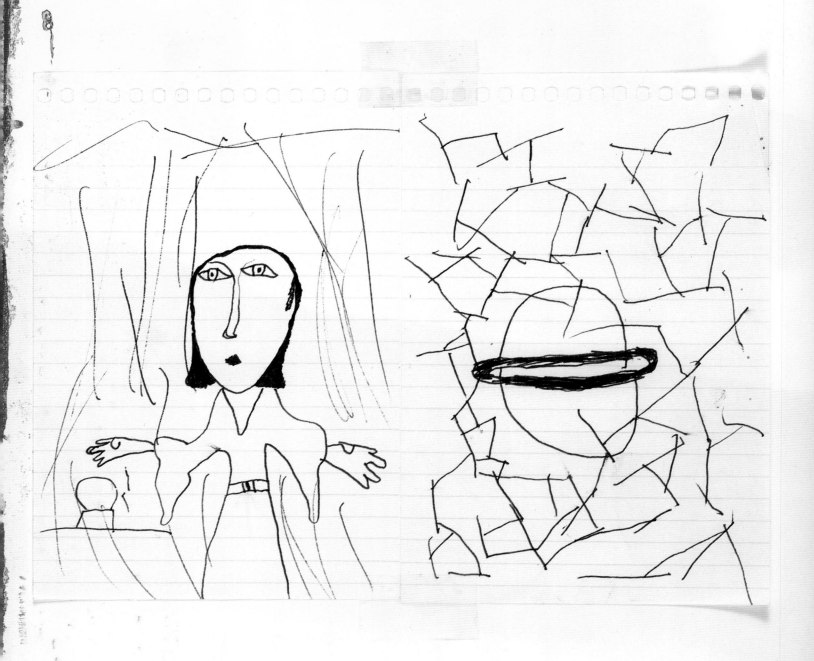

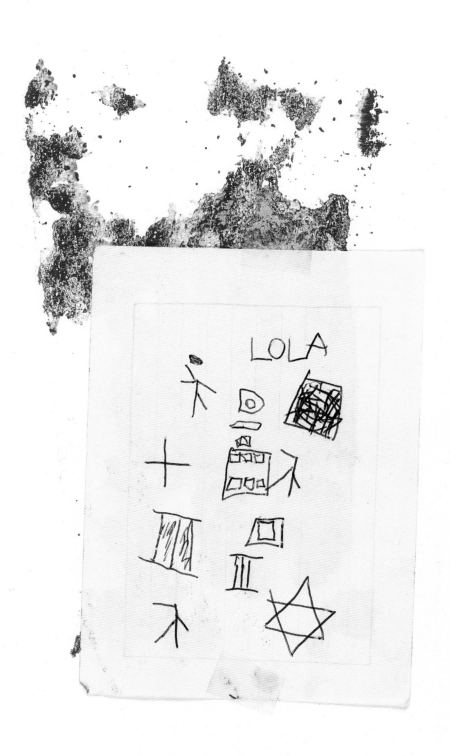

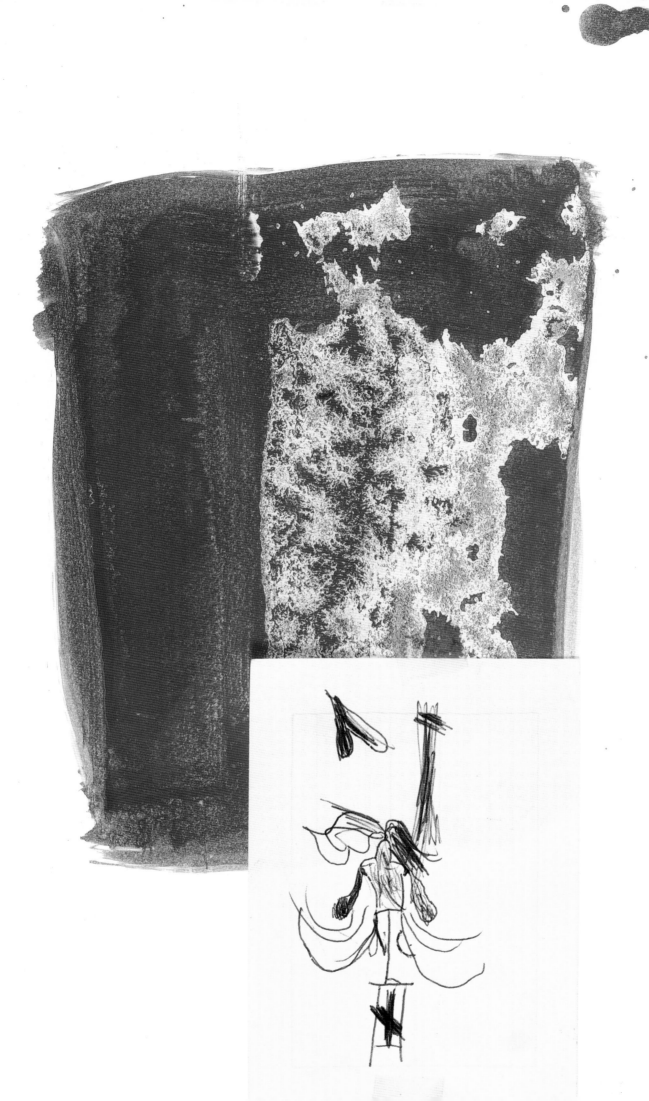

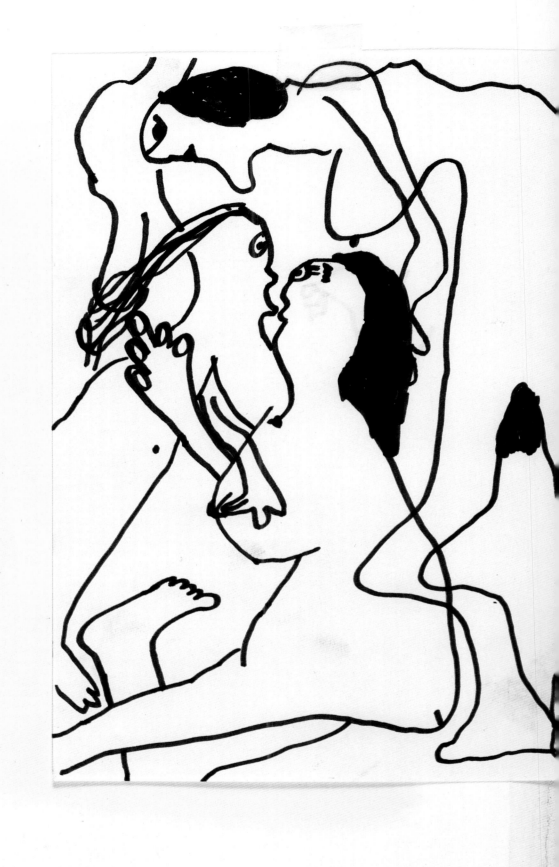

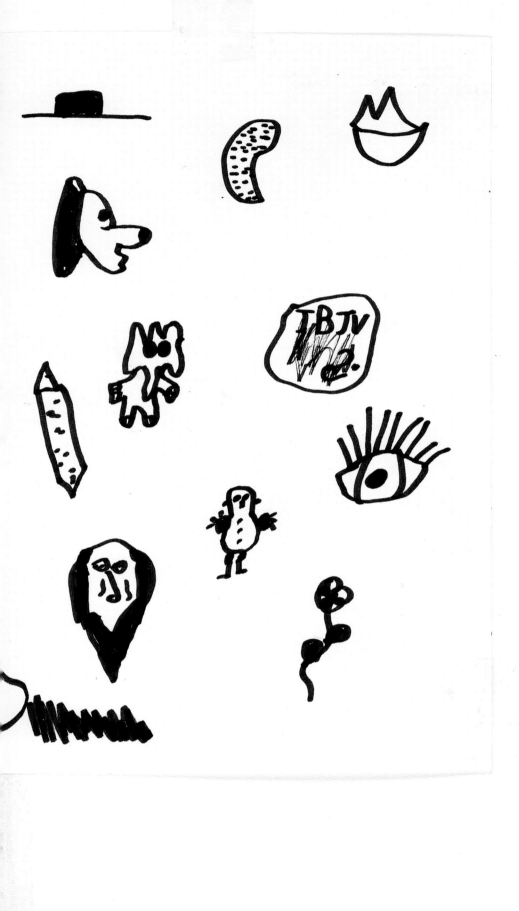

The bikini show

show

by LOLA

somebody fawnd
Somebody fawnd her
her.

They lived

happily

ever after